IMAGES
of America

BURLINGTON
FIREFIGHTING

On the cover: Members of the Burlington Fire Department pose in front of the 1895 Fire Station No. 3 on Mansfield Avenue in the early 1900s. Capt. William Carty, pictured sitting next to the driver of this American LaFrance truck, rose to the rank of chief engineer in 1939. (Courtesy of Captain Woodman.)

IMAGES
of America

BURLINGTON FIREFIGHTING

Liisa Reimann
Foreword by Capt. James M. Woodman

ARCADIA
PUBLISHING

Copyright © 2006 by Liisa Reimann
ISBN 0-7385-4612-7

Published by Arcadia Publishing
Charleston SC, Chicago IL, Portsmouth NH, San Francisco CA

Printed in the United States of America

Library of Congress Catalog Card Number: 2006928530

For all general information contact Arcadia Publishing at:
Telephone 843-853-2070
Fax 843-853-0044
E-mail sales@arcadiapublishing.com
For customer service and orders:
Toll-Free 1-888-313-2665

Visit us on the Internet at www.arcadiapublishing.com

Contents

Acknowledgments 6

Foreword 7

Introduction 9

1. Evolution of a Fire Department 11

2. A New Era 23

3. Firehouses 41

4. Firefighters 49

5. Occupational Hazards 67

6. Lighter Moments 75

7. Fires 87

Acknowledgments

Although I did not know it at the time, the seed for this book was sown during a first-year historic preservation graduate course at the University of Vermont. Without the course assignments and encouragement of professors Robert McCullough and Tom Visser, or my classmates' diligence, the idea for this book would never have surfaced. Much credit goes especially to Amanda Ciampolillo, Devin Colman, April Cummings, James Duggan, Alexis Godat, Todd Goff, Sara Gredler, Joseph Hoefferle Jr., Sara Jamison, Lindsay Jones, Gweneth Langdon, Laura Need, Susanna Prull, Doug Royalty, and Gregory Tisher. Their research has been invaluable.

I have made some great friends in the process of compiling this collection of photographs. The enthusiasm, warmth, generosity, and openness of the men and women of the Burlington Fire Department have been overwhelming at times. To Chief Engineer Michael O'Neil, his command staff, and all the firefighters past and present who have put up with my pestering questions and frequent visits, I extend my deepest gratitude. They have welcomed me to their firehouses and homes, insisted that I join them for meals, made me feel like part of the family, and enriched my life in ways I cannot begin to articulate. I especially must thank Capt. James M. Woodman for entrusting to me the department's collection of materials, as well as his own, and also for working tirelessly to secure me access to many other sources of photographs, documents, and personal stories. Heartfelt thanks also go to Gary and Pat Francis, Melvin "Bud" and Doris Monell, and the Burlington Firefighters Association for their time, generosity, materials. It has been a challenge to piece together all the stories and events, and although I am sure I may have missed several things, I sincerely hope I have not made any gaping omissions or grievous errors in telling them.

I must also thank my daughters Hannah and Maddie for not griping too much when I dragged them with me to do my research and Big, the love of my life, without whom this project would have sunk to the bottom of Lake Champlain.

Foreword

From humble beginnings dating back to 1808 as a series of independent brigades protecting a village with leather buckets, the Burlington Fire Department has evolved into a sophisticated organization along with the city it protects. Remembering our past is important: it shows respect to those who came before us, thanks those who have made our job better and safer, and acknowledges the men and women who forged the great reputation we now enjoy among the citizens of Burlington.

A fire department has deeply ingrained traditions, but access to the history and materials can be challenging. This book is a critical step in preserving the history of the Burlington Fire Department and giving the community it serves a lasting testament to the trials, tribulations, and triumphs associated with all aspects of firefighting.

—Capt. James M. Woodman
Burlington Fire Department.

Office of the Chief Engineer Fire Department
City of Burlington Vermont
January 1st, 1876

AN ORDER IN RELATION TO FIRE ALARMS

On and after this date the following fire alarm signals will be observed by the Members of the Fire Department of this City.

1st. The Fire Alarms will be sounded by the following: The City Hall Bell, Unitarian Church Bell, Baptist Church Bell, and the Whistle at the Planing mill of Messrs. Shepard, Davis & Co.

2d. In sounding alarms, the following rules will be observed: Upon an alarm of fire, the several Bells and Whistle will sound the usual alarm, (several rapid taps,) to be immediately followed by a slight pause, when the signals will be given denoting the District wherein the fire is located, vis:

For Ward 1,—Winooski, usual alarm, and one stroke of bell and one whistle.

For Ward 2,—East half of North Ward, alarm and two strokes bells and whistle.

For Ward 3,—West half of North Ward, alarm and three strokes bells and whistle.

For Ward 4,—Centre Ward, alarm and four strokes bells and whistle.

For Ward 5,—South Ward, alarm and five strokes bells and whistle.

For the Lumber District North of Maple street, a succession of rapid alarms.

For the Lumber District South of Maple street, one continued and prolonged sounding whistle.

3d. In case the location of the fire be not certainly known, the persons sounding the alarms will sound only a general fire alarm until the location thereof is communicated to them, when they will proceed to give the proper alarm.

When the location of a fire is known to the persons having charge of the alarm bells and whistle to be on the Colchester side of the Winooski River, they will not sound the alarm except upon the order of one of the Board of Engineers.

It is hoped and expected from our citizens, when giving an alarm of fire, that they will communicate with the persons having charge of the fire alarm Bells and Whistle, or either of them, as stated in this order, as near as possible the location of the fire, so that the proper signal may be speedily and properly given to the Department.

Nothing in this order will operate to excuse members of the Fire Department from a faithful observance of their Company By-laws, relative to repairing to their several engines or apparatus, and assisting to take the same to scene of fire.

HIRAM S. WHITE
Chief Engineer, Burlington Fire Department

The Order in Relation to Fire Alarms was issued by Chief Engineer Hiram S. White on January 1, 1876. This order spelled out the combinations of bells and whistles that would signify fire alarms in the various city districts. The alarms were sounded by the Burlington City Hall, the First Baptist Church bells on St. Paul Street, and the First Unitarian Universalist Society church bells at the head of Church Street, as well as the Shepard, Davis and Company Planing Mill whistle.

Introduction

The history of the Burlington Fire Department is an extremely rich one. It is intricately connected to the settlement and development of the city of Burlington. As the community grew in the 19th and 20th centuries, so did the institution of firefighting in general and the Burlington Fire Department specifically. It has been a process shaped by changes in technology, architecture, engineering politics, civic engagement, and economic forces.

Initial protection for the community was largely an informal system of independent fire companies, their formation usually prompted by a devastating fire often related to burgeoning local industries. Burlington's early volunteer fire companies each had a fire warden whose authority at fires was supreme. Other members operated the apparatus or served as hook-and-ladder men or the bucket brigade. Two models of operation were generally employed: the first was a private, all-volunteer organization with little or no public support, although members were exempted from military duties and tax obligations. The second model was based on commercial sponsorship, with hose companies established to protect the interests of resident industries.

In 1866, when the City of Burlington was incorporated, the city paid for these existing companies' firefighting equipment and operating expenses and installed a municipally paid chief engineer to oversee the volunteer force. The companies themselves, however, remained largely autonomous; they elected their officers and members, and they designed and paid for their own uniforms, among other things.

The year 1895 was a landmark one in which the department evolved from this variety of independent, rival volunteer companies into one cohesive, paid municipal department. It was a transition that presaged events in other Vermont communities, and it was spurred partly by two major fires that destroyed the J. R. Booth lumber mills and, embarrassingly, one of the city's own fire stations.

One small book cannot possibly document the entire history of the Burlington Fire Department, which now spans over a century. There are many stories still to be told, and my hope is that this will be the first of many efforts to make them available.

THE UNIFORM IS SUPPOSED TO SAY SOMETHING ABOUT YOU. YOU GET IT FOR NOTHING, BUT IT COMES WITH A HISTORY, SO DO THE RIGHT THING WHEN YOU'RE IN IT.

A silent reminder hangs in the halls at Central Fire headquarters, on South Winooski Avenue.

One

Evolution of a Fire Department

The Burlington Fire Department can trace its roots back to 1808. Although it was not incorporated as a career organization until 1895, several bucket brigades and, later, private companies existed to provide fire protection before that time. The earliest of these was the Burlington Fire Company, which was incorporated in 1829 after a fire destroyed the old courthouse. Shown here is one of the original leather helmets worn by the Ethan Allen Fire Engine Company No. 4, which was formed in 1857.

The early fire companies were all male and functioned as elite social clubs throughout the 19th century. As companies grew, so did their pride and professionalism—along with the concept of brotherhood, still a strong element today. This poster advertised the First General Firemen's Muster in Vermont, held in Burlington on July 2, 1858. The competition tested not only the firemen and their skills but also their apparatus.

Members of the Ethan Allen Fire Engine Company No. 4 pose on the corner of Church and Bank Streets in 1877. The company grew to be one of the most powerful of all the city's private fire companies, with its fire warden Moses Murray becoming the chief engineer of the first paid Burlington Fire Department in 1895. In 1896, it was renamed the Ethan Allen Club by charter amendment of the legislature. The club is still in operation today.

This hand-drawn hose cart was a gift to the members of the Ethan Allen Engine Company by the Trojan Hook and Ladder Company No. 3 of Troy, New York, in 1874. It served for 21 years until 1895, when Burlington transitioned from an all-volunteer to a career fire department. In 1996, firemen belonging to the Ethan Allen Club (where the cart is now on permanent display) arranged for its restoration by William Pinney of the nearby town of Charlotte.

CHAMPION HOSE COMPANY OF THE UNITED STATES.

Barnes Hose Company No. 7, Burlington, Vt.

1. Hudson,		10. Henry,	
2. Hathaway,		11. Hudson,	
3. Thompson,		12. Johnson,	
4. Reagan,		13. McGrath,	
5. Newton,		14. Shea,	
6. Scott,		15. Slayton,	
7. Croto,		16. Lynch,	
8. McCartey,		17. Bingham,	
9. Finnerin,		18. Hallihan,	

Winner of 1st National Prize, $500.00 in Gold, Championship Belt, and Prize Cart, Chicago, Dexter Park National Tournament, Sept. 4th, 1878. By 18 Men, drawing Cart (weight, without Hose on, 500 pounds), and 350 feet of Regulation Hose on it : running 300 yards to Hydrant, attaching to Hydrant, reeling off 300 feet, breaking couplings, (Caswell's) three full turns, putting on pipe, tight connection,—1st trial, 63½,—2d trial, 61½, —Average time 62½ seconds. Best on Record,—400 yards ground covered.

Winner of 1st Prize $100 00, July 4th, 1878, Middlebury, Vt., Running 40 rods to Hydrant, (drawing 300 pound cart) attaching to Hydrant, laying 300 feet Regulation Hose, Putting on pipe in 42¾ seconds. Best on Record,—320 yards ground covered.

Entered according to Act of Congress in the year 1878, by JOHN J. SHEA, in the office of the Librarian of Congress at Washington, D. C. All rights reserved.

Burlington's Barnes Hose Company No. 7 gained recognition as the "Champion Hose Company of the United States" in a Chicago tournament in September 1878. In the competition, 18 men drew a 500-pound cart loaded with 350 feet of hose for 300 yards, reeled off 300 feet of hose, broke couplings, and connected it to a fire hydrant.

The Barnes Hose Company won this United States silver championship belt in 1878 for its feats. Competing against 22 other teams from around the country, the company's average time for the three trials was 62.5 seconds. The prize was $500 in gold, the belt, and a hose cart.

This is one of the original woolen felt caps worn by members of the Barnes Hose Company No. 2. The Barnes boys were not the only fire company to win competitions, however. The Boxer Engine Company No. 3 won the state championship three times in succession, in the early 1900s, with Bill Powell managing the winning team in 1914.

Shown are a leather fire bucket and two Bresnan cellar nozzles. When a fire in a basement prevented access, firefighters would cut a hole in the floor, attach one of these brass nozzles to the hose, and drop it down. The pressure of the water coming through would then cause the nozzles to spin, much like a garden sprinkler. It was an early attempt at fighting cellar fires that would ultimately prove ineffective, due to the small nozzle openings. Today such fires are fought with a single, large nozzle and essentially flooded as quickly as possible.

This pre-1900 photograph shows men with early firefighting apparatus: two hand-drawn hose carts and a horse-drawn steam fire engine, possibly the Button Steam Fire Engine, which the city purchased in 1892 and assigned to Station No. 3 on Mansfield Avenue.

The hose as a firefighting tool was developed around 1870. Its advent signaled the end of the hand-pump engine era, as fire companies were now able to battle fires with a pressurized stream of water by hooking up to fire hydrants. Where previously all wagons had been hand-drawn, the increased weight created by early, leather hoses led to the harnessing of horsepower for transport. Shown here with an exercise wagon around 1900 are fireman Burt Mills (left) and Donald Carty (center), whose father, William Carty, worked his way up to the rank of chief.

Fire Station No. 1, pictured here, served as the Burlington Fire Department's headquarters until 1926, when the Central Fire Station was built a block to the east on North Winooski Avenue. Built as the Ethan Allen House in 1889, it also served as police headquarters for many years.

Vintage speaking trumpets, pictured here, are part of the permanent collection of equipment and memorabilia at Central Fire Station. Speaking trumpets such as these presaged the bullhorn. Some were used in service while more ornate examples were used as presentation trumpets, or as awards for special achievements and at firemen's musters.

The fire stream range finder tables date from the 1920s. These sliding cards helped firefighters calculate the distance water could be projected through a hose with an attached nozzle of specific dimensions.

This postcard shows the transition from horse-drawn to mechanical apparatus. Mailed from Burlington on October 7, 1914, to a boy in Bennington, the card contained one line: "Well... how would you like to be a fireman up here." It was signed "Karl," and the postage was 1¢.

The first motorized chief's car is pictured at Fire Station No. 3 on Mansfield Avenue around 1914. It was housed here, along with a two-horse hose wagon and a steam fire engine. Driving Chief Engineer Charles A. Niles is Peter Ashline. Niles served as chief engineer from 1904 to 1913.

Pictured above is a leather captain's helmet. Rank was indicated by specific insignia: a round design with five crossed trumpets for the chief engineer; a round design of three crossed trumpets for the deputy or assistant chief; for captains, two trumpets with bells pointing down as shown on this helmet; and a Maltese cross with member number for all other firefighters.

While the shape of fire helmets has been relatively consistent throughout the years, their construction has evolved significantly. The most popular helmets among U.S. firefighters have traditionally been produced by Cairns and Brother, Inc., of New Jersey. With a long history dating back to the 1830s, the company still manufactures the original 1836 New Yorker fire helmet. Components of contemporary helmets include leather, high-temperature resin, fiberglass, and ballistic-grade Kevlar.

22

Two
A NEW ERA

These apparatus are parked outside Central Fire Station. When Central Fire Station was completed in 1926, the Burlington Fire Department was completely motorized.

The Burlington Fire Department poses outside Fire Station No. 3 around 1920. Note 3.5-foot-tall, 46-year-old Jo Viens (13th from left), reportedly the department mascot. Viens later appeared in

Tennessee touted as the "missing link" during the Scopes Monkey Trial of 1925.

By the early 1900s, fighting fires in taller buildings necessitated longer ladders, and 75-foot lengths became available for the first time. As ladder and truck size grew, horses could not pull the vehicles as easily as before. Motorized trucks thus replaced the horse-drawn apparatus, also increasing response time dramatically. Chief Carl Stockwell is shown standing by the cab of this ladder truck; the four men in plain clothes near him are fire commissioners. Standing on the truck second from the left is Abner Lauzon.

When the four-bay Central Fire Station opened in 1926, shown here with one of its early ladder trucks, it represented the latest in firefighting technology as well as firehouse design. At that time, the department was entirely motorized.

Sec. 7. The arrangement of time for vacation for the several members will be made by the chief engineer.

House Rules

Rule 1. The members of each station shall at least once each day sweep out and dust and at least once each week scrub their respective houses.

Rule 2. No person shall sleep in a fire station without the consent of the captain and permission will not be given persons not connected with the department to frequent the houses at unreasonable hours.

Rule 3. Occupants of beds will be held responsible for any disorderly use of, or damage caused to bed or bedding, and the person in charge of each station shall report to the chief any violation of this rule.

Rule 4. After retiring, the occupant of each bed must refrain from loud talking, or in any manner disturbing the sleep of others.

Rule 5. Houses must be closed at 10.30 p.m., except in case of fire.

Rule 6. No bed shall be occupied after 6.30 a.m. except in case of fatigue from fire duty.

Rule 7. Loud or boisterous talking or use of profane language in or about the houses will not be tolerated.

Rule 8. Intoxicating liquors shall not be kept or allowed to be drunk in the houses.

Rule 9. Gambling is strictly prohibited.

Rule 10. Religious and political discussions must be avoided.

Rule 11. All visitors shall be treated politely, but habitual lounging will not be permitted in the company's quarters, nor will visitors be allowed to speak disrespectfully of any officer or member connected with the department. Intoxicated or otherwise disorderly persons will not be allowed around quarters under any circumstances.

Rule 12. No information relative to the business or affairs of the department shall be furnished parties not connected therewith, except as authorized by the chief.

Rule 13. Sec. 1. Whenever at a fire the services of members are not actually required they shall remain at or near their apparatus unless otherwise ordered.

Sec. 2. In case of errors or mistakes in responding to alarms of fire with apparatus the person in charge shall be held responsible.

Sec. 3. No person other than permanent men shall be allowed to ride on apparatus when answering or returning from alarm. No company shall leave the fire grounds, or take away the apparatus without orders from the officer in command, transmitted through the company commanding officer of such company.

The 1932 Rules and Regulations of the Burlington Fire Department gave captains full command of their stations and fires when they were the first on the scene. It also instructed drivers to avoid running over hose with the apparatus; specified uniform requirements for each rank; required decorum to be observed en route to, from, and at fires; gave each member of the permanent force two weeks annual vacation; and asked all department members to "impress upon their friends and families the need of refraining from unnecessary [telephone] calls [to the firehouses]."

Pictured are a Seagrave ladder truck and the c. 1939 Engine No. 2 equipment list. Burlington's 1934 population of approximately 25,000 was protected from fire by a department of 82: a chief engineer, assistant engineer, 3 captains, 8 chauffeurs, and 28 hose-and-ladder men. Chief Engineer Carl Stockwell, who drew a salary of $2,501 for the year, recommended in his annual report that "the old solid tires on the aerial ladder truck be replaced with pneumatic tires. This should be done at once . . . as these tires are in very poor condition and are liable to give out any minute."

Shown is a 1967 American LaFrance foam truck. In 1965, fire department vehicles traveled 9,388 miles, responded to 2,051 calls (645 of which were fire calls while the remaining 1,406 were first aid calls), and spent 1,428 hours in service.

Shown here is a c. 1939 captain's examination. The promotion process has evolved greatly since then. Although testing for movement between certain ranks still exists, captains are now selected from a pool of qualified, experienced firefighters and appointed by the chief engineer.

29

Training takes many forms. This wooden tower was erected directly behind Fire Station No. 3 on Mansfield Avenue around 1940. It afforded firefighters critical instruction in rappelling, laddering, and other skills in a controlled environment. Today, in lieu of a tower, the Burlington Fire Department uses the city's plethora of tall buildings for similar exercises.

This is a bird's-eye view from the training tower behind Fire Station No. 3. The tower was demolished in the 1950s and replaced two decades later by a concrete one in Burlington's Intervale district.

This four-story, 50-foot, concrete training tower was built in Burlington's Intervale in 1972. Mayor Gordon Paquette attended the dedication, shown here. Although he was invited to try his hand at rappelling, the mayor declined. Chief Patrick Brown made the tower available for training to other fire departments in northwestern Vermont upon request.

This 1939 document is an "application for membership." Today's application process is vastly different and begins with a comprehensive testing system, which involves rigorous written and physical components. Requirements include dragging a 165-pound dummy 200 feet, raising a 24-foot ladder, opening a fire hydrant, and chopping through a roof (simulated) with 50 blows of an axe.

Report forms in times past were simple compared to the multipage, computer-generated documents required today. Carl Stockwell, chief engineer from 1914 to 1938, ran an efficient and disciplined organization. For example, when the department switched to a two-platoon (or shift) system, Stockwell mandated that off-duty firefighters were not permitted to leave city limits unless they were on their authorized two-week vacation period.

This is a detail of a vintage Gamewell alarm box, now displayed at Central Fire Station on North Winooski Avenue. Each box had an individually assigned number; when an alarm was pulled, its code was transmitted to the alarm room, and firefighters from the appropriate station would then be dispatched to the scene.

With well-worn and heavily thumbed pages, this is fireman Herman Stockinger's 1940 guide to the city's alarm boxes. The Fire Alarm Division used the second floor of Fire Station No. 3 as a repair shop during the 1940s and stored supplies such as reels of wire, poles, and miscellaneous related items in the basement.

In the alarm room at Central Fire Headquarters in 1953 is Lyman Burdo, who was one of four alarm operators who dispatched firefighters to calls. The alarm room is now housed within the police department on North Avenue.

Herman Stockinger kept many notebooks and records of fire department activity. In this c. 1941 notebook, he recorded that he "Drove Ladder One 2 years and 13 weeks before I received Driver's pay."

Annual spring ladder training drills tested firefighters on their ladder skills. There were two basic tenets to laddering: holding on and not falling off. This drill was held at Central Fire Station. Notice that the original double doors, which swung in, are still in place in this photograph.

34

Chief Edward "Dutch" Duball conducts a training drill with firefighters, shown here rolling hose in front of Central Fire Station on a cold winter day. Behind them is Engine No. 1, a 1953 Oren pumper. Apparatus today is custom-built to fit the needs and criteria of each particular department and station. Engines housed at Station No. 3 in particular are designed specifically for the door and bay of the firehouse, which are smaller and narrower than in newer stations. There is only minimal clearance afforded it in getting in and out, and as one battalion chief says, "It's a wonder we don't take out the wall more often!"

Engine No. 1, a 1953 750-gallon Oren pumper, streams by the Howard Opera House on the corner of Bank and Church Streets, en route to a call. Engines were formerly designed without a top, or roof, to allow firefighters a better view of the scene and situation when responding to a fire alarm.

Chief Engineer Edward Duball (left) and master mechanic John "Sauce" Poirier stand by a Burlington Fire Department truck around 1955. That year, the department's operating budget amounted to $211,342.99—the bulk of expenses going to salaries ($182,466), fire alarm repairs ($8,720), fuel ($4,052), and uniforms ($3,745). The department responded to 495 calls, 34 of which were in South Burlington, 1 in Essex Center, and 1 in Jonesville.

Ambulance service was not officially assumed by the Burlington Fire Department until 1962, prior to which it was provided by the Burlington Police Department. Pictured is the 1964 International ambulance. Firefighters like to say that the policemen assigned to the ambulance grew frustrated with the job, drove the bus to Central Fire Station, parked it, yelled "It's yours now!," and ran back to their station in the old Ethan Allen firehouse.

The Burlington Fire Department took its aerial operation to the May 1938 Kresge's fire, with fire hooks, a brass fire extinguisher, and pompier ladders at the ready.

This view also shows the aerial ladder at the Kresge fire in May 1938. The ladder was extended and retracted by means of a hand-crank mechanism. The pompier, approximately 14 feet long, enabled firefighters to ascend buildings from the exterior. They hooked it onto a window sill, climbed up the rungs, disengaged it, and threw up to the next level, repeating the process as needed.

Melvin "Bud" Monell (far right) stands with several other members of the fire department and Ladder 1 in the early 1970s. Others pictured include Steve Vidurek, Charles LaBombard, Richard Trombley, Greg Frazier, Dick Desautels, Ed Bouchard, Dave Modica, and Dick Whalen.

The Burlington Fire Department celebrated a century of service in 1995. The department invited the public to view memorabilia and photographs at Central Fire Station and at the Elmwood Avenue Post Office, which issued this limited edition centennial cancellation stamp to mark the event.

Chief Engineer Dayton Contois (back row, 23rd from left), firefighters, and administrative personnel turned out in force for the centennial photograph outside the 1926 Central Fire Station on South Winooski Avenue. Contois served as chief from 1995 to 2002, at which time the present chief engineer, Michael O'Neil (seen here in the front row, 15th from left), was appointed.

Three
FIREHOUSES

In his 1883 annual report, the chief engineer recommended that Burlington "erect buildings that the firemen can point to with pride." The Ethan Allen Engine House, which would later become Fire Station No. 1, located on lower Church Street and built in 1889 by local architect A. B. Fisher, was just such a firehouse. When it was completed, it stood as the tallest building in the city. Shown is the former Ethan Allen firehouse in 2006. During its renovation, the original bell, which spent many years at the Shelburne Museum, was restored to its place in the firehouse tower.

In 1926, the Ethan Allen Engine House was replaced as the fire department's headquarters by the newly built and aptly named Central Fire Station, located on South Winooski Avenue. The police department used the Ethan Allen Engine House until 1969, after which it fell into disrepair and was eventually slated for demolition in 1973. Community advocates saved the building and secured its stabilization, but it was not until 2004 that it was fully restored and reopened as the Firehouse Center for the Visual Arts.

Formerly the station for Barnes Hose Company No. 7, this became Fire Station No. 2 and housed a two-horse hose wagon when the Burlington Fire Department became a paid department in 1895. Burlington's second-longest-serving firehouse, it is located on North Champlain Street where it was operational for the better part of a century and was reportedly the last Burlington firehouse to use horses. It is now the Firehouse Family Shelter.

The present Station No. 2 was built on North Avenue in 1980 and replaced the Champlain Street firehouse. Station No. 2 primarily services Burlington's historic Old North End and houses a variety of fire and rescue apparatus, as well as classroom space and the city fire marshal's offices. Until it was disbanded in the late 1990s, the Fire Alarm Division was also located here.

The Star Hose Company No. 2 was housed on North Winooski Avenue. The conversion of Burlington's conglomeration of volunteer companies to a single, paid, and organized municipal department in 1895 saw manpower go from 243 volunteer firemen to 47 paid firefighters and callmen, distributed among four stations citywide. After the transition, the 1885 station was converted into a school and later remodeled for mixed use with commercial space on the lower level and an apartment above.

The A. C. Spear Hose House is pictured before 1895. This was the first Fire Station No. 3, located at 58 Colchester Avenue. It was lost to fire in the early hours of January 9, 1895. Fire apparatus, horses, and sundry trappings were spared, but the building was completely destroyed. Traced to the furnace in the cellar, the fire was an embarrassment in a landmark year.

Chief Engineer Moses Murray recommended that the lost firehouse be replaced by a structure more resistant to fire. Builder D. W. Clapp constructed a magnificent new Fire Station No. 3 just around the corner on Mansfield Avenue. Built of brick and stone, the firehouse featured a tall hose tower (which had become part of Vermont firehouse design by the late 1800s), two apparatus bays, and two Snow Sanitary horse stalls, purported to be odorless and perpetually clean and dry.

This photograph illustrates some of the transportation challenges created by cumbersome lengths of ladders. As ladder lengths increased, longer trucks were developed to accommodate them, but fire stations themselves were not as easily adapted. When Fire Station No. 3 was built in 1896, such advances in apparatus were not adequately anticipated and one ladder could not fit inside. According to department history, a new window was installed in the rear of the building and the ladder simply extended through it.

In 1940, Chief Newton Lavery recommended that Fire Station No. 3 be remodeled to one story to cut the cost of heating and maintenance. With the horse stalls empty and only four men on duty, the building was now seen as overly large. The new configuration, however, seems hazardous today, as the private quarters were placed next to the engine bay, and firefighters are eager to see the building restored to its former configuration and splendor. Reputedly the oldest Vermont firehouse still in operation, No. 3 is the third busiest station in the city. It is also said to be haunted, and firefighters to this day refuse to venture up to the second floor after dark.

Made obsolete by the advent of rubber hose, the drying tower was omitted from Central Fire Station's design. Representing the latest in firehouse design, the horse stalls and haylofts of earlier firehouses were replaced by wider, taller, and uninterrupted engine bays running the length of the building. Substantial foundations were required to withstand the weight of an entire fleet of vehicles. The first level housed apparatus, administrative offices, and the alarm room, while private quarters were located on the second floor. In the original configuration, 15 bedrooms formed a ring around a central kitchen and dayroom, while four brass poles provided quick access to the apparatus floor below. Although the alarm room has been replaced by administrative offices and one of the sliding poles removed to allow the installation of a weight room, the station appears much as it did 1926.

The busiest station in the city, Central Fire Station today houses Engine No. 1, Tower 1, Rescue 1, Car 12, and the chief's car. Like Station No. 3, it is also said to be inhabited by supernatural beings. Theories point to former captain Joe Maynard as the resident ghost, as well as spirits who followed the fire trucks back from fatal fires. This has, of course, been exploited by some of the department's more ardent pranksters over the years.

Originally the Howard Hose House, this was remodeled in 1910 as Fire Station No. 5 and placed into service in 1911. When completed, it had space for a two-horse hose wagon and two horses, along with accommodations for three firemen. Its service as a firehouse was short lived, however; by 1924, it housed Chief Stockwell and his Studebaker. It was redesignated as Station No. 4 for a time, until it ceased operating as a firehouse altogether. It remains a private residence today.

There have been several incarnations of Fire Station No. 4. As the Burlington Fire Department struggled to meet demand for fire protection in a rapidly expanding city, firehouses were built, occupied, abandoned, and reinstituted accordingly. Station No. 4 has existed in the basement of city hall, next to the site of the present Central Fire Station, and also within the former Howard Hose House on Union Street. In 1950, a new building on North Avenue was constructed to answer the fire and safety needs of the city and designated as Fire Station No. 4. It was identical in design to the new Station No. 5, which was built on Ferguson Avenue in the south of the city that same year. Expanded around the original structure in 1991, Station No. 4 primarily services Burlington's New North End and houses a police substation on the first level.

Fire Station No. 5, on Ferguson Avenue, is pictured around 1960. It was built in 1950 along with a new Station No. 4 on North Avenue of identical design. Both stations housed a single 1948 750-gallon Buffalo pumping engine, as is pictured here. From left to right are Anthony Beauvais, Emerson Bouchard, Bob Boucher, Louis Maynard, George Brousseau, and Charles Alberts.

Pictured is Fire Station No. 5 as it appears in 2006. The original 1950 building was demolished to make way for a larger two-story fire and rescue building, which was completed in 1991. Almost identical to the remodeled Station No. 4 constructed at the same time, No. 5 also houses a police substation on the first floor.

Four
FIREFIGHTERS

Burlington firefighters pose outside Fire Station No. 1 on Church Street around 1919. Standing sixth from left is Barney Francis, grandfather of retired firefighter Gary Francis Sr. and great-grandfather of current firefighter Gary Francis Jr. That year, the department's inventory included 11 horses, 3 of which were deemed unreliable; three two-horse hose wagons; a ladder truck; a chemical engine; a chief's automobile; 10,250 feet of rubber-lined hose; and 14 three-gallon hand extinguishers. It responded to 143 alarms and came in under budget, expending only $28,978.56 of its allotted $29,000.

Appointed in 1909 as a ladderman, Peter Cornelius Ashline was first assigned to Station No. 4 on South Winooski Avenue. By 1915, he had risen to the rank of captain, serving first at Station No. 5 on South Union Street and later at Fire Station No. 1 on Church Street, shown here. He is buried in St. Joseph's Cemetery, located on Archibald Street in Burlington.

Peter Ashline is shown in the back row, third from the left, in this c. 1910 photograph. He retired in 1934, a year in which the department operated four fire stations and a force of 82 men, responded to 370 alarms, and ran over budget by $3,222 at a total cost of $68,526. Charles A. Niles, who served as chief engineer from 1904 to 1913 is seated in the center of the front row.

Shown are Burlington firefighters outside Fire Station No. 3 in the early 1900s. The upper level of the station has been used as private quarters and as a training room, as well as for storage of hazardous materials and miscellaneous items. One notable item housed there has been "the wheelchair," which would roll across the floor of its own volition after dark and disturb those in the living room below. Firefighters who have spent time stationed here swear to hearing footsteps and items being dropped on the floor and admit that investigations into these occurrences have traditionally been left until daylight returns.

The station captain and the firemen pose at Station No. 3 on Mansfield Avenue in the early 1900s. Burlington's growth in the 1800s, combined with expansions at the University of Vermont, the emergence of the Mary Fletcher Hospital, and growth in commercial enterprise, was too much for the existing firefighting infrastructure. Fire Station No. 3 proved critical in alleviating some of this strain.

Pictured are members of the Burlington Fire Department outside Fire Station No. 3 on Mansfield Avenue, probably at shift change. Sitting next to the driver on this early American LaFrance truck with solid rubber tires is Capt. William Carty, his rank indicated by the double rows of buttons on his uniform. Regular firemen had a single row of buttons. A second captain stands second from the right.

Burlington firefighters are pictured on the American LaFrance engine at Station No. 3 in the early 1900s. Among them are Burt Mills (next to driver) and Capt. William Carty (third from left). Carty served as chief engineer in 1939.

This undated photograph shows Carl Stockwell at far right. Stockwell, chief engineer from 1914 to 1939, was an enthusiastic proponent of modernization and frequently urged the city to replace the old and heavy horse-drawn apparatus with speedier and more cost-effective motorized vehicles. He himself was noted for the red and chrome Studebaker convertible he used as a chief's car.

The Burlington Fire Department poses in May 1931 outside Central Fire Station. Among those pictured are Chief Carl Stockwell (first row, eighth from left), Asst. Chief William Carty (to Stockwell's left), and four officers to his right.

Clockwise from left are driver Herman Stockinger, Francis Martin, and Frank Degan in the winter of 1940. Martin's helmet indicates he was assigned to Engine No. 1, which continues to operate out of Central Fire Station.

55

Burlington firefighters display a two-horse Seagrave hook-and-ladder truck apparatus with hard rubber tires, hitched to a contemporary vehicle of the time. Kept as reserve apparatus by 1924, it carried a total of 320 feet of ladder with the longest individual ladder length at 65 feet.

Firemen are pictured here at the base of the training tower behind Station No. 3 on Mansfield Avenue. They are, from left to right, (first row) J. Fortin, R. Tatro, T. Finneran, G. Lord, Frank Degan, E. Lafayette, B. Mills, G. Burt, A. Viens, Tex Murphy, and E. King; (back row) P. Barrett, J. Desrochie, C. Flynn, B. Francis, P. Francis, H. Willette, N. Lavery, C. Levee, R Whalen, T. Bissette, and C. Langlois.

Chief C. Newton Lavery, chief engineer of the department from 1940 to 1943 and 1945 to 1949, is shown as he was depicted in the 1941 Annual Firemen's Ball program. The schedule worked by firefighters in that year was a 24-hour-on and 24-hour-off rotation. Today the rotation consists of a 24-hour shift followed by 48 hours off.

Outside with an American LaFrance aerial ladder, city employees have a little fun in the winter of 1940. From left to right are police officer Ernie Francis, father of retired firefighter Gary Francis Sr., along with firefighters Herman Stockinger, Frank Degan, and Francis Martin.

With the chief engineer and assistant chief behind them, firefighters pose for a photograph. Future chief engineer Edward Duball (seated third from the left) has a band around his cap that indicates he has achieved promotion to either lieutenant or captain.

This is the appointment letter for Edward Duball, who joined the fire department in 1925 and earned the nickname "Dutch." He served for 30 years and eventually became chief engineer in 1955, one year before his retirement.

Chief Edward Duball (with cigar) poses in front of Engine No. 1 at Central Fire Station. Duball was chief engineer from 1954 to 1955, at which time he retired.

Chief Edward Duball's white leather helmet is now a prized piece of memorabilia at Central Fire Station. Duball was the only chief to wear what firefighters fondly refer to as a "safari" helmet.

Chief Duball poses for a photograph with members of the auxiliary unit around 1955. Six new fire hydrants were installed in the city that year, bringing the total to 487, 67 of which were private.

From left to right are Bernard Thomas, Arthur Curtis, Donald Leblanc, and Jim Fercenia, with Joseph Snow on the shoulders of Curtis and Leblanc.

The beloved and respected Chief Raymond "Bobo" Pratt helps himself to dinner in the kitchen at Central Fire Station. Pratt joined the department in 1939 and served as chief engineer from 1965 until his retirement in 1970. His dedication and commitment to the fire service also led him to serve as president of the Vermont Fire Chiefs Association and as Vermont's delegate to the association's board of directors. He also assisted newly formed departments in northern Vermont with their training.

The shift is on duty on July 2, 1970. Among those present are Lt. Gary Francis Sr. (fifth from right) and Arthur "Six" Pepin (second from right). In 2006, the Burlington Fire Department operates three 24-hour shifts: A, B, and C. Approximately 80 firefighters and administrative personnel serve the department in 2006.

61

Joseph "Captain Joe" Maynard still stalks the halls of Burlington's historic firehouses, according to some. Legend has it that his ghost causes disturbances at Fire Station No. 3, and that until a new alarm system was installed at Central Fire Headquarters, the bell outside his former room never needed winding. To this day, firefighters are reluctant to use his old room. Maynard and his brother Louis, shown here in April 1976, served together in the department for many years.

62

Lt. Gary Frazier moves quickly at a fire at Edmunds Junior High School in April 1976. His white helmet denotes his rank. By around 1980, white helmets were reserved for chief officers—battalion chiefs and the chief engineer.

63

Patrick Brown served as fire chief from 1971 to 1982. Some of his orders raised a few eyebrows, including order No. 57, which prohibited firefighters from "arm wrestling, wrestling, boxing, squeezing hands, pressure points to the neck, and generally just fooling around." He is buried in Lakeview Cemetery on North Avenue, and his headstone admonishes, "I told you I was sick."

Melvin "Bud" Monell poses in 1961. Monell gave this portrait of himself to his wife, Doris (sister of Arthur "Six" Pepin), for Mother's Day—and, as she recollects, it was "the best present." He later left Burlington to assume a position with the South Burlington Fire Department, where he served as chief engineer until his retirement.

Standing from left to right with one of the department's pumpers are Burlington fire captains Bucky Labombard, Bobby Fortin, Art Curtis, Roland Moran, Joe Linane, Dicky Whalen, Val Dion, and Chet Brunell. The photograph was taken in 1977.

This image shows the B-shift engaging in a practice burn, a critical element of training, in September 1989. The sacrificial structure was the former Millington House off Plattsburgh Avenue. Pictured standing from left to right are Dayton Contois, A. B. George, Larry Snow, Jim Woodman, Chris Gilbert, Scott Moody, Al Bright, and David Gale. In the first row are Ellen Perry, Seth Lasker, and Rob Mullin.

Shown is the Burlington Fire Department assembled outside Central Fire Station around 1988. Although the city around it has changed extensively, Central Fire Station still appears much as it did when it was completed in 1926.

Five

Occupational Hazards

On his day off, firefighter Gary Francis (second from right) happened upon the scene of an accident and jumped in to assist. In 1962, when the Burlington Fire Department incorporated emergency medical services into its operation, firefighters assigned to the rescue wagon had only minimal training in basic first aid. In its first year of service within the Burlington Fire Department, the rescue wagon answered 954 medical calls. Formal training for the rescue squad was not offered until 1970. Today EMT training and certification are required of all new firefighters.

In 1963, the Burlington Fire Department's rescue wagon was the only unit offering emergency medical services to the Champlain Valley area. By 1995 an additional unit had been added to the fleet and Rescue 1 alone was responding to approximately 3,000 calls within the city of Burlington itself. In this photograph, Gary Francis (left) assists as a fellow firefighter Steve Olio works to revive a child. The child was rescued from a fire on Ferguson Avenue by James Cavanaugh. Several generations of the Francis family have served the city of Burlington: Gary's grandfather was a Burlington firefighter, as is his son now, and his grandson is fast following in his footsteps too. Francis's father served the city as a police officer.

Death cannot always be averted. Here Burlington firefighters have the terrible task of extracting a victim from the scene of a fatality. Whether or not freezing temperatures played a role in this death is unclear; nonetheless, while this part of the job must be expected, it is a reality that is often difficult to accept.

Lt. Ernest Trombley, Ernest Charbonneau, and Charles Brigham dug frantically to find a fire hydrant after being dispatched to a call on College Street in the winter of 1968. They never found the hydrant, but luckily it had been a false alarm: steam from a roof vent had caused a concerned citizen to sound the alarm.

On March 17, 1942, fire officials arranged for a practice blackout on Riverside Avenue as a test for driving during a real such event. The test, which the mayor and police chief both claimed they had neither authorized nor been notified of, resulted in a head-on collision between the fire department's service truck and a delivery truck driven by an auxiliary fireman. The four firemen involved in the crash sustained injuries of varying degrees; luckily none were life threatening.

Other apparatus collisions, such as this one involving Rescue 1, have also occurred throughout the department's history. On Christmas Eve 1963, Engine No. 2, speeding from the North Champlain Street station to an alarm, collided with a convertible at Main and South Champlain Streets. Firefighters Anthony Beauvais, Art Curtis, and Bernard Thomas were injured in the crash along with the driver of the convertible.

This photograph shows a collision on Cherry and Pine Streets between a Seagrave truck driven by Bobby Fortier and an Oldsmobile coupe driven by a Mr. Kramer. The type of injuries sustained by the coupe's occupants are unknown, but the extensive damage to the driver's side suggests they may have been quite serious.

Pictured is the scene of a c. 1940 accident on Main and South Union Streets. Winter weather conditions were a determining factor in the accident. The speeding pumper could not make the turn on the icy road and overturned, spilling hose and equipment into the street.

On May 14, 1939, the No. 3 pumper assigned to Central Fire Station collided with an automobile at "death corner," the intersection of Pearl and Willard Streets. Capt. Abner Lauzon and his driver Clarence Langlois were both treated and released for minor injuries, but the occupants of the coupe were not so lucky. The car's driver bore a concussion, while one of the teenaged passengers suffered fractured bones and the other suffered a head injury.

These are the remains of an aerial ladder truck around 1950. The truck jack-knifed; what remains left of the cab is at left—the winch mechanism for raising the aerial ladder is on the platform, and the ladders extend to the back of the photograph, still on the wheel base. The seat has disengaged from the vehicle and slipped to the ground to at right.

Frank J. Osicky joined the Burlington Fire Department on August 13, 1966. A little more than a year later, in December 1967, he suffered a knee injury while battling a blaze at the Union Station Hotel on lower Main Street. Complications from the injury would eventually prove fatal, and Osicky lost his life on September 11, 1969. The Burlington Fire Department honored the 29-year-old father of four with a formal funeral, an honor reserved for those killed in the line of duty.

Capt. Joseph J. Linnane, a 20-year veteran of the Burlington Fire Department, died in the line of duty on October 21, 1979. Shown here is his casket being carried from St. Mark's Catholic Church on North Avenue, after the formal departmental funeral mass.

The Burlington Fire Department has been luckier than many other departments in that relatively few have died in the line of duty. One particularly tragic death, however, was that of Deputy Chief George Carty. Directing his men at a fire in 1963, he accidentally brushed up against a live wire and was electrocuted. A husband and the father of two small children, he was 42 when he died. The fire was thought to have been set intentionally.

Pictured is the funeral procession of Joe Snow Sr., as the casket passes Central Fire Station. Snow served one of the longest appointments as assistant chief, from 1947 to 1975. His son Joe "Chubby" Snow Jr. also served as a Burlington firefighter.

Six
Lighter Moments

This formal dinner was held in the early 1900s. Second and third from the right, in the second row, are the chief and assistant chief, discernable by their double rows of buttons and trumpet lapel pins.

By the time of this firemen's parade on August 11, 1910, the Burlington Fire Department had existed as a paid career company for 15 years. But in 1887, discussions about a paid, unified department were just beginning and overshadowed the firemen's parade of that year. A report in the *Burlington Clipper* notes that the September 29 parade lacked "the old rivalry that used to stimulate each to double vigilance to do their utmost."

Another parade (above) fills the streets of Burlington. The Burlington Firefighters' Association held its first annual ball in 1922. The program for the ball, complete with an attached pencil, had a dance card inside where partygoers noted their partner for each dance. Balls continued until the 1940s, and in 1963, an attempt to revive the event met with disappointing results.

The Burlington Fire Department celebrated Burlington's 150th anniversary in June 1923. Capt. Peter Ashline (in white pants) and the Burlington Fire Department in black face were part of the three-day celebration.

Burlington firefighters have served their community on many levels. A long-standing tradition has been reaching out to those in need, especially children, during the holidays. In this c. 1930 photograph, firemen are repairing toys and readying them for distribution to the city's underprivileged children at Christmastime.

Distractions are critical when one is holed up with several other individuals for 24 hours at a time. Shown here at Central Fire Station with Chief Carl Stockwell are the 1932 city champions with their 10-year-old mascot, Georgie Kirby, and coach, William Hammond. In a three-game tournament, they beat the police department 26-4, 30-6, and 18-4.

Everyone wants to be a fireman. In this unidentified photograph, three boys pose wearing white officers' helmets.

This photograph of Tom Bessette (left, wearing hat) and friends was taken outside Fire Station No. 3, after it had been remodeled following Chief C. Newton Lavery's recommendation in 1940. Note the window on the west wall, where the second apparatus bay had been converted into sleeping quarters for firemen.

Chief Edward Duball and firefighters work on mailers for the March of Dimes on January 3, 1955. From left to right are Arthur Muir, Bernard Thomas, Ed Mellow, Arthur "Six" Pepin, Chief Duball, Bob Boucher, John Poirier, and Joseph Snow.

Chief Edward Duball receives, on behalf of the Burlington Fire Department, an E&J resuscitator donated by the Veterans of Foreign Wars. The event took place around 1955.

Edward Duball poses with a friend. This monkey lived next door to the fire station on North Champlain Street and apparently used to frequent the firehouse, sauntering over at will to visit with the firefighters.

A Christmas party is held at Central Fire Station around 1965. A tradition that has endured, the annual children's Christmas party is now held at St. Mark's church on North Avenue. The church affords a larger function space as well as amenities such as an old-fashioned bowling alley, pool/billiards, and Ping Pong.

A friendly rivalry exists between the fire and police departments today as they challenge one another annually to a game of hoops, still one of the distractions of choice. Other activities include broomball against the Burlington Police Department on Lake Champlain each winter and participation in community events such as the annual Mardi Gras parade.

The rivalry that existed between the early, independent volunteer companies still persists within the Burlington Fire Department. Firefighters are famous for their pranks, which can alleviate what is often a stressful, traumatic job, and those in the Burlington fire service are no different. Here the crew at Central asserted their dominance and superiority over Station No. 2 by "kidnapping" and ransoming their mascot, a toy cardinal. The joke continued for much of 1993, culminating in the ultimate horror: Station No. 2's receipt of a small box of bones when they refused to acknowledge the "seriousness" of the situation.

The Burlington Fire Department still actively supports several charitable causes, one of which is the Muscular Dystrophy Association, as shown by this 2000 photograph. Burlington firefighters raised funds during the Sixth Annual Andrew Shepard Memorial Firefighters Golf Tournament. Pictured (from left to right) are firefighters B. Gariety, S. Vidurek, S. Bourgeois, B. Druin, G. Francis Jr., E. Webster, M. Sicard, B. Maher, D. Gale, S. Costello, and J. Woodman (front left).

Seven
FIRES

The Hotel Burlington and Walker Block, on the corner of St. Paul and Main Streets, succumbed to fire on January 8, 1910. The *Burlington Free Press* reported that not since President Taft's visit to the city the previous July had so many people gathered in a single location. The fire started in a sink room on the third floor of the hotel and spread rapidly, entering the adjoining Walker Block through what was thought to be a fireproof brick wall. Tenants within the Walker Block did not evacuate their belongings, as firefighters at the scene assured them that the structure would not burn. Unexpectedly, they lost everything. Five firefighters, including Assistant Chief George Burt, caught by surprise and trapped on the roof of the burning building, had to be rescued.

The fire that devastated the Hotel Burlington and the Walker Block burned for 20 minutes before fire crews arrived. Hotel employees had tried to put the blaze out themselves first, but a strong south wind thwarted their attempts. Six hours of the fire department's best efforts could not save the buildings. Peter Ashline, on shift at Station 4 that day, suffered grave burns to his neck and chest. An unidentified woman narrowly missed serious injury when she failed to hear the clanging alarm bell of the exercise wagon, returning to the scene after retrieving more hose. At the last minute she realized her predicament, but slipped and fell while attempting to get out of the wagon's path. Fortunately the driver was able to rein the horses to one side and avoid trampling the woman.

Fires have historically reshaped entire communities. In Burlington, fire and urban renewal are arguably the two greatest factors responsible for the loss of integral structures. The prevalence of fires in Burlington's increasingly dense downtown such as this one, which destroyed the Parkhill Block, prompted the city to establish an inner-city fire district mandating that all new construction be of noncombustible materials.

In the 1880s, Burlington's lumberyards employed approximately 1,000 people and exported products to Europe, South America, and the Pacific. They also supplied the local New England area with a large variety of lumber and produced vast amounts of doors, blinds, and sashes. The Shepard and Morse Lumber Mill burned on February 19, 1913.

A previous fire occurred at Shepard and Morse in July 1910. It originated in a building that housed the boilers, shavings store room, and machine shop. Fanned by winds from a freak tornado, it spread quickly through piles of shavings. Although it engaged firefighters for many hours, the blaze caused relatively little damage.

On February 19, 1913, hundreds of spectators watch the Shepard and Morse Lumber Mill burn.

Shown is the aftermath of the Sugar Factory Fire of April 1918. Located on Flynn Avenue in the south of the city, the Chocolate and Maple Sugar Factory Company of Vermont was completely devastated by the blaze.

The Burlington Traction Company was granted permission to operate buses in 1926, and trolley service was discontinued in 1929 as a result. In 1929, while hundreds watched, the last Burlington streetcar was given a fiery, symbolic sendoff at the corner of Main and St. Paul Streets.

The exact location of this fire is unknown, but, judging by the vehicles and fire apparatus employed, the year was likely around 1941.

On the afternoon of Sunday, May 29, 1938, fire broke out in the 1927 structure that housed Kresge's 5, 10, and 25¢ variety store. As firefighters manned a hose in the store, an explosion propelled Capt. Charles Sutton, Clarence Langlois, Edward Duball, and Philip Plankey out the door and into the alley beyond. The explosion also impeded several others trying to contain the blaze.

Pump operation was regularly suspended for several hours on Sundays, causing decreased levels of water in the city's reservoirs. Ironically this coincided with the time that the Kresge fire was first discovered. The water department hastily engaged lakefront pumps at greater speeds than normal and was able to provide an adequate water supply.

Boosting water pressure, five fire engines were at the scene of the May 1938 Kresge fire, but they proved no match for the dense smoke, which overcame several firefighters. In all, 10 men sustained injuries or smoke inhalation. Water used in quelling the blaze flooded basements of adjoining properties, in some cases to levels of several feet.

With assistance from Winooski and Fort Ethan Allen Fire Departments, Burlington firefighters worked for nine hours to contain the May 1938 Kresge fire. A 25-man police force worked to keep order among the thousands of spectators watching events unfold. Loss to the building's owner and surrounding businesses was calculated at $150,000.

The Milner Hotel once occupied the block at Church and Cherry Streets in Burlington. Around 2:00 a.m. on Valentine's Day, February 14, 1940, as guests were sleeping in the renamed New Sherwood Hotel, fire broke out in the upper west portion of the block. At first, it seemed as though the fire could be contained and extinguished without much difficulty as it appeared confined to the upper two stories.

As dawn approached on February 14, 1940, the Milner-Sherwood fire appeared to have died down, but in reality it was working its way around to the north side of the building where the roof protected it from the streams of water being pointed at it by firemen. The *Burlington Free Press and Times* reported that the "most spectacular phase of the fire" occurred at 6:30 a.m., when flames pushed through the roof and, bolstered by strong winds, reached heights of 50 to 100 feet.

Among the 160 hotel guests who escaped the fire was a Burlington woman who lost the entire manuscript of a novel she had been crafting for 20 years—a novel just on the cusp of publication. The Milner Block also contained several businesses in addition to the hotel accommodations of the Sherwood. The fire devastated the Sears and Roebuck store on the first floor, the Royale Grill, and Joseph Langlois's barbershop, and it heavily damaged the J. C. Penney store and several others.

Winds carried sparks from the Milner-Sherwood fire alarming distances, causing fears that nearby buildings would also catch fire. Mayor Burns found a live ember on the steps of Burlington City Hall, two blocks away, and ashes floated to the southernmost part of the city. The *Burlington Free Press and Times* reported that Burlington firemen responded to four additional fires that day, February 14, 1940. The burnt-out hull of the once magnificent building was eventually torn down, with a total assessed loss of $500,000. Lt. Francis Martin noted, "Was at scene for 82 hours, saved 19 people."

With the temperature at 32 degrees below zero, more than 100 firefighters battled the Milner-Sherwood fire in February 1940. The entire 43-member department was on site, assisted by the Essex Junction, Milton, Vergennes, St. Albans, Fort Ethan Allen, and Montpelier Fire Departments. Fort Ethan Allen soldiers also came to assist with evacuees, as did many volunteers. Local businesses, including Henry's Diner, Kresge's, Woolworth's, Grand Union, and the Salvation Army, furnished sandwiches, doughnuts, and gallons of hot coffee.

In the aftermath of a fire, Deputy Chief Frank Heron of the fire investigation unit tries to identify the source of the blaze.

Firefighting in freezing temperatures presents the additional danger of frostbite. Shown here around 1950 is Joseph Fountain, encrusted with ice while battling a fire in the bitter cold of a Vermont winter. In subzero weather, it is especially critical for firefighters to take extra measures to keep water from spraying into their boots, as frozen limbs have tragically led to amputation at least once.

The Van Ness Hotel on the corner of Main and St. Paul Streets was completed in 1869 and then enlarged in 1891. In 1951, a fire destroyed the 50-room building.

This view shows the spaghetti-like tangle of multiple hose lines employed in fighting the Van Ness Hotel fire.

After the 1951 fire, the Van Ness Hotel was demolished. The Howard Bank then purchased the site and erected a building to serve as its main office.

This aerial view shows the damage caused to the Van Ness Hotel in 1951. Pine Street is shown at right. Some 40 years earlier the Van Ness had taken in residents and employees of the Hotel Burlington, when it was lost to fire on the afternoon of January 8, 1910.

An underground tunnel reportedly provided passage from the Van Ness to another hotel located at 131 Main Street. The tunnel afforded working women seeking to go back and forth between the two buildings an opportunity to do so undetected.

Chief Duball examines the scene at the Van Ness fire.

Even a chief has to pull the hose sometimes. Chief Edward Duball (left) fights a blaze alongside his crew. He was a working chief rather than an administrator. This fire was likely at the old boathouse on Burlington's waterfront.

Chief Edward Duball (right) surveys the scene after a fire. Unless he was in gear and fighting a blaze, Duball reportedly always wore his dress uniform.

A training session is under way at Burlington Airport with a new American LaFrance foam truck in the 1960s. Airports provide unique challenges for fire departments in terms of chemical and other hazards as well as human safety concerns. Although the Vermont National Guard has jurisdiction over the airport, the Burlington Fire Department still conducts regular training exercises should they be called out to assist with an emergency.

A housing development in Burlington's New North End, the Northgate apartment complex succumbed to fire during construction in 1967. Most buildings were unharmed, although two were completely destroyed. An additional building suffered minor damage and was salvaged.

Firefighters and off-duty police officer Ralph Blow survey the scene of the Northgate complex fire.

The Quarterdeck restaurant burned on February 15, 1970. The restaurant occupied the first floor of the Parker building on Church Street, and apartments were located above. At one point, two people—a man and a woman—appeared in one of the apartment windows. The man reportedly leaned out and yelled to rescue crews saying, "Forget her—take me!" This photograph shows firefighters Robert Fortin and Herbert McCormick on the department's new Aero Chief platform.

From left to right are Dayton Contois, H. Francis, D. Modica, F. Blondin, and J. Ledoux. The February 1970 Quarterdeck blaze was the inaugural fire for the new Aero Chief aerial ladder truck. Reports that a murder suspect from Rutland died in the fire were never confirmed.

During this residential fire on Howard Street in 1970, firefighter Armand Bourgeois suffered a blow to the face, resulting in the loss of several teeth. The event served as the catalyst for the fire department's acquisition and installation of face shields on all firefighters' helmets.

The Ethan Allen Club was formed in 1857 as the Ethan Allen Engine Company No. 4 and had a two-fold mission: to serve the community and to provide a social environment for members. In 1905, the club purchased a residence on College Street and converted it into a clubhouse. Ironically, the building was lost to fire in December 1971. Reconstruction of the building took a much more contemporary form than the historic building, but it retained many features, including a bowling alley, ballroom, and exercise facilities.

A blazing fire lights up the night in the 1970s. It quickly spread through the dense residential neighborhood, damaging several homes, some irreparably.

Pictured is the mobile emergency services unit at a fire in the 1970s. The Burlington Fire Department has traditionally taken a progressive role in the type of medical services provided to the community. Firefighters are certified to administer various forms of intravenous therapy and advanced cardiac life support, including defibrillation and cardiac drugs. Since an engine company can often arrive on scene before the ambulance, patients are assured of fast competent care from the onset of the fire department's involvement.

Mazel's Department Store, on North Street, succumbed to a devastating fire in the early 1970s.

A tanker truck rollover and fire necessitates specialized apparatus and firefighting techniques. Burlington firefighters receive training through in-house and state-sponsored programs. The National Fire Academy, founded in 1975 and located in Emmitsburg, Maryland, offers additional vital training opportunities.

Designed by prominent local architect Ammi B. Young in 1831, the Episcopal Cathedral Church of St. Paul was 86 feet long by 40 feet wide, and its tower soared to 75 feet. It was expanded in 1851 and again in 1868, when the nave was enlarged to accommodate an additional 880 parishioners. A Burlington landmark for over a century, the entire structure was gutted by what was called the biggest fire of the year, on February 15, 1971.

Shown ablaze in 1979, the Episcopal Cathedral Church of St. Paul was located one block away from the 1867 Cathedral of the Immaculate Conception, which was reportedly the first New England church fully designed and constructed as a cathedral. One year after this fire destroyed St. Paul's, the Cathedral of the Immaculate Conception also burned, leaving a gaping hole in Burlington's downtown.

Burlington firefighters were unable to save St. Paul's. Their impossible task was additionally hindered by minor mechanical difficulties with the Aero Chief ladder truck. The apparatus was quickly repaired, however, and used to quell the blaze raging in the bell tower.

Although the church was lost, firefighters were able to rescue the cathedral's tower bell and main doors. They were stored at the old Ethan Allen firehouse and later incorporated into the new cathedral constructed on Pearl and Battery Streets. The massive stone stoop, part of the original building, as well as the facing stone from the east front and tower, were also incorporated into the reconstruction.

Shown are the remains of the north wall and the chapel of St. Paul's in February 1971. University of Vermont buildings and grounds personnel donated time and equipment to assist the cathedral gardeners in relocating many plants and trees from the devastated site. As a result, two large maple trees and a flowering crab tree were replanted on the grounds of St. Anselm's Chapel on the University of Vermont campus.

Shortly after 1:00 a.m. on Saturday, October 9, 1971, two men were seen running from the loading bay of the Strong Theater building complex on Main Street just as flames erupted. A snow fence being stored there was apparently doused with gasoline and set ablaze. Volunteers assisted firefighters in raising ladders to the building's upper floors where residents were trapped. The building (which housed the Strong Theater, where Kinko's is now located), several businesses, and 13 apartments were destroyed despite the efforts of 200 firefighters from Burlington, South Burlington, Winooski, Colchester, Mallets Bay, and Essex Junction. With the demise of the theater, Burlington firefighters lost a favorite haunt—its proximity to the firehouse had allowed them to enjoy movies between calls. When the alarm went off at the firehouse, a bell had sounded at the theater to alert the firemen.

The Mayfair department store on Church Street burned in 1972, one of a string of arsons in the city. The arsonist was in the building at the time of the fire and had to be plucked off the roof.

Written on this photograph, taken at the Cathedral of the Immaculate Conception fire and now displayed at Central Fire Station, is a single word: vigil. Some 200 firefighters from eight departments battled the blaze, which began on the night of Monday, March 14, 1972, intentionally set by a former altar boy. As embers continued to glow in the aftermath, fire crews remained on hand for several days, watching to make sure the fire did not have a chance to flare up again.

The Centers Department Store, which occupied an L-shaped building on Bank and Church Streets, was completely wiped out during the night of July 19, 1974. The three-alarm fire spread quickly and engulfed three additional buildings surrounding the department store. The fire was apparently caused by an air compressor within the refrigeration system of the store's snack bar.

The July 1974 fire spread from the Centers Department Store to the Lash Furniture building on Bank Street, shown here. Some 300 firefighters, 21 fire trucks, and almost four million gallons of water could not prevent the devastation to this area. The Lash building, gutted by the blaze, continued to smolder for several days afterward and had to be taken down after a large crack in the masonry created fears of collapse.

The Black Cat Café was a Burlington landmark for almost a quarter of a century. Owned and operated by Charles Chantis and his wife, M. Josephine, it opened in the 1930s. Mrs. Chantis baked pies and goods for the café, and a live band entertained patrons on the second floor. In 1977, fire struck the Black Cat Café.

Locals often began their nights out at the Sherwood Hotel and then made their way over to the Black Cat Café on Bank Street for the second-floor show. The 1977 fire started with an explosion and burned so ferociously that the building had no chance of being saved.

A gaping hole was left in Burlington's urban landscape after the Black Cat Café fire was finally extinguished. The café was never rebuilt. Today the site features a McDonald's and provides access to the Burlington Mall.

Located on the shores of Lake Champlain, the campus of Rock Point School consists of several imposing buildings set on 150 acres. A fire in 1979 caused extensive damage at the boarding school, which has a student body of approximately 40.

Rock Point School burns in the 1979 fire. The school was later rebuilt and continues its 70-plus-year tradition as a small, residential school for teenagers in grades 9 through 12.

Tragedy struck on the University of Vermont campus with the Kappa Sigma fire in the 1970s. Two fraternity brothers trapped in the cupola of the building died in the blaze.

Engaged in the fire at the Kappa Sigma fraternity house is the 80-foot extension snorkle truck. Similar in design to the familiar "cherry picker" popularized by utility companies and arborists, this truck was purchased for $65,000. Utilized for both rescue and firefighting operations, its acquisition meant fewer runs for one of the department's aging and increasingly cumbersome ladder trucks.

Lt. Gary Francis is at the top of the ladder handing an unconscious victim of the Kappa Sigma fire to Armand Bourgeois. Standing next to Francis on the roof is Ray Giyette.

The Old Circus Building off Flynn Avenue was already a total loss when fire crews arrived at the fire in the 1970s. Maintaining complete calm in a tense situation, Capt. Tom Cannon coolly paced off the distance from trucks to the fire to calculate how much length of hose would be required in effectively tempering the blaze.

Shown is Loomis Street in January 1979. Burlington photographer Dick Gendron specialized in fire photography. Many of the photographs the Burlington Fire Department has of the significant blazes of this era were taken by Gendron. Ironically the bulk of his collection and original negatives were lost in a fire. Pictured are D. Contois and R. Desautels.

Laid out in 1871, Loomis Street is comprised of some of Burlington's oldest residential buildings, some of which are extremely large. This photograph shows a structure fire on Loomis Street in 1979.

In this unidentified photograph, the Aero Chief and firefighters combat a blaze in the city's inner fire district. By 1975 Burlington's population was nearing 40,000, and the fire department was increasingly plagued with malicious false alarms—268 that year alone, a significant increase from the 168 reported in 1974.

Shown here is one of the many churches in Burlington that have been lost to the ravages of fire. This fire occurred around 1982.

This photograph of the Hunnington Block on the corner of Main and St. Paul Streets was taken from the former Hotel Vermont building. A vat inside the Burlington Bagel Factory sparked the fire, which spread quickly and caused considerable damage to the building.

Firefighters on the fire escape of the Hunnington Block called to crews below for an additional hose line. From the top are Pete Walsh, Jim Woodman, David Gale, Walt Harris, and Seth Lasker.

ACROSS AMERICA, PEOPLE ARE DISCOVERING
SOMETHING WONDERFUL. THEIR HERITAGE.

Arcadia Publishing is the leading local history publisher in the United States. With more than 3,000 titles in print and hundreds of new titles released every year, Arcadia has extensive specialized experience chronicling the history of communities and celebrating America's hidden stories, bringing to life the people, places, and events from the past. To discover the history of other communities across the nation, please visit:

www.arcadiapublishing.com

Customized search tools allow you to find regional history books about the town where you grew up, the cities where your friends and family live, the town where your parents met, or even that retirement spot you've been dreaming about.